Happy coloring for Halloween

This book belongs to

Copyright © 2016 by Queenie Wong.
All rights reserved.
No part of this book may be reproduced in any form without written permission from the author.

ISBN-13: 978-1537398709
ISBN-10: 1537398709
First published in United States in 2016
Illustrations by Queenie Wong
Wonger0050@yahoo.com.hk

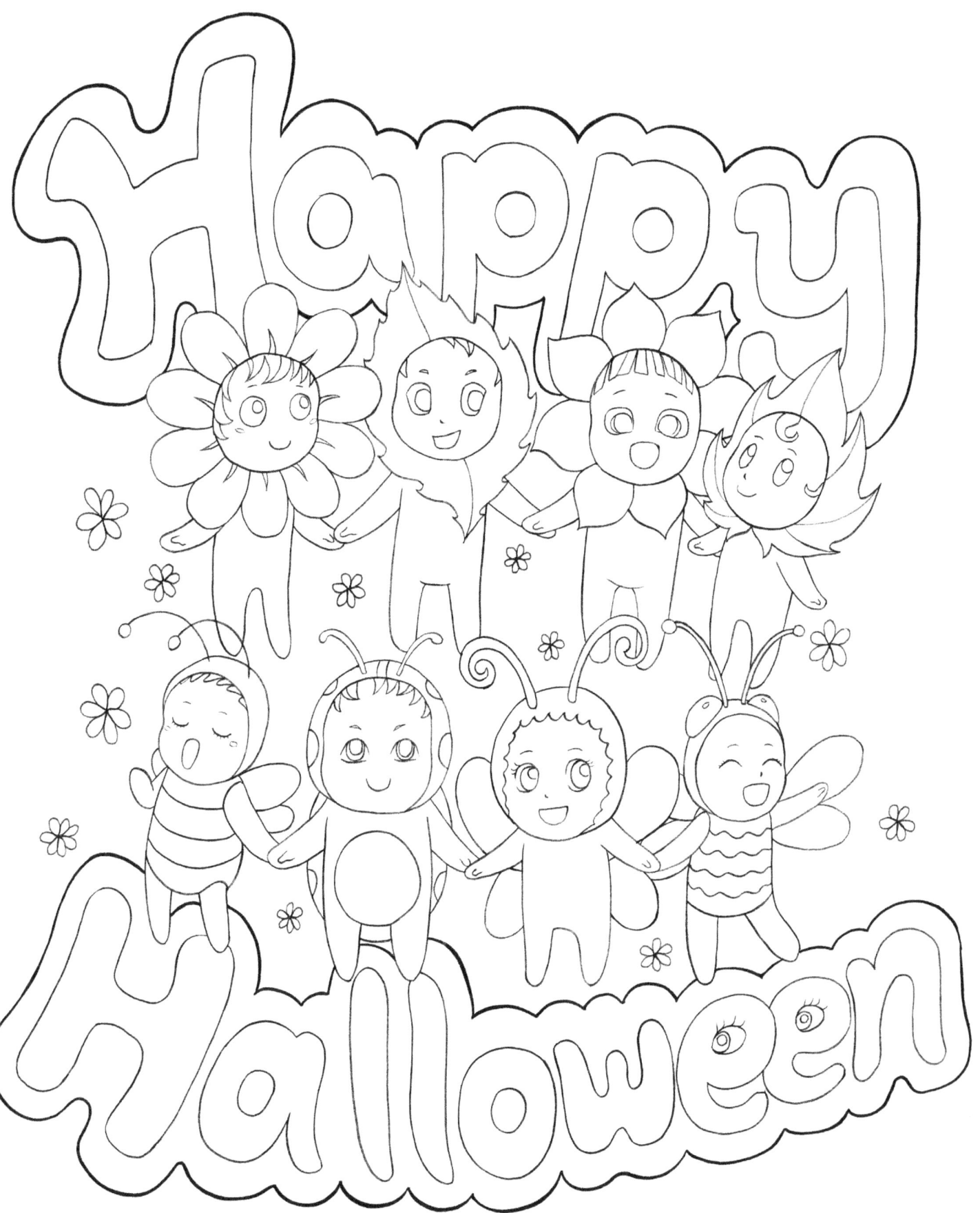

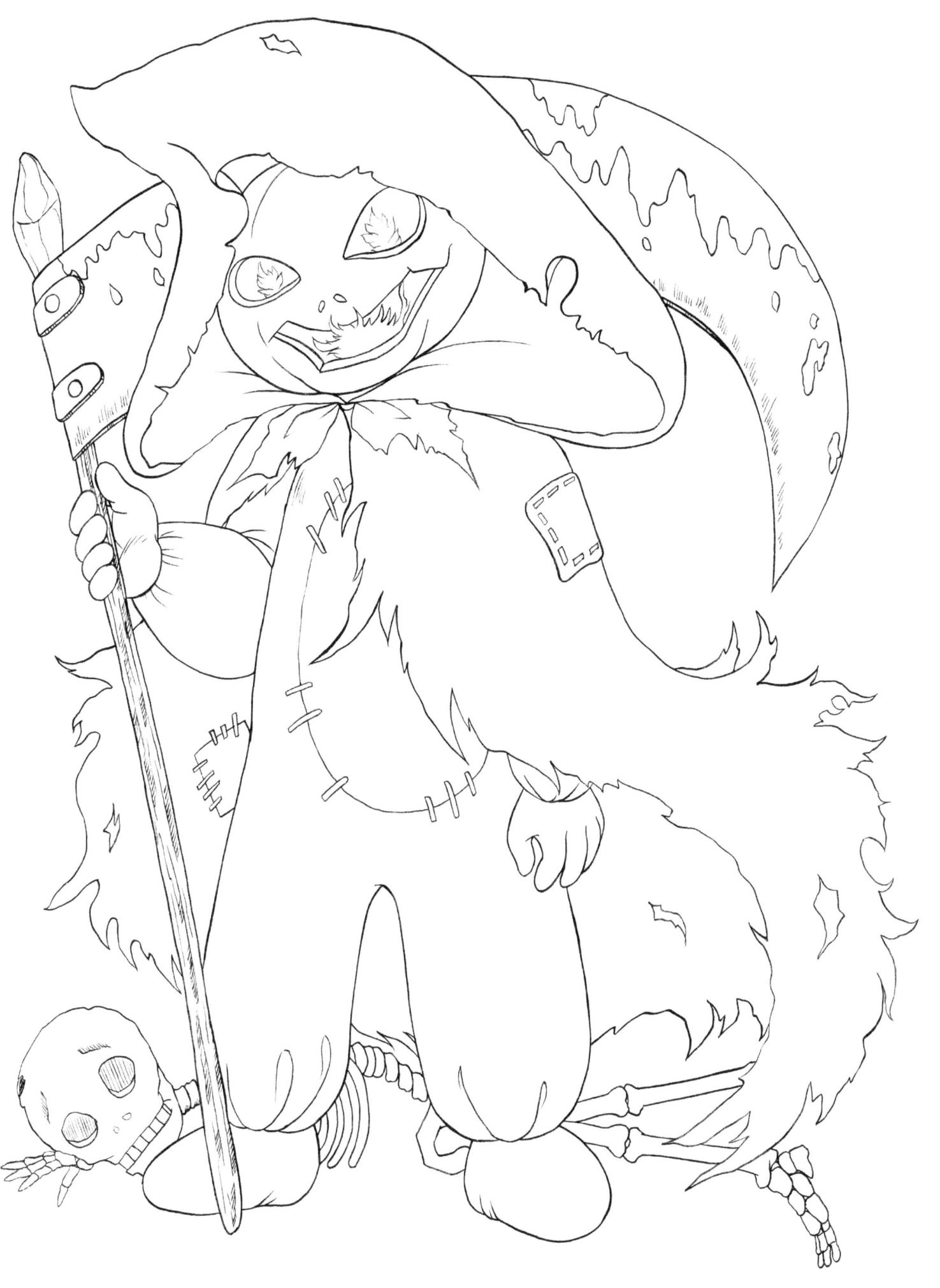

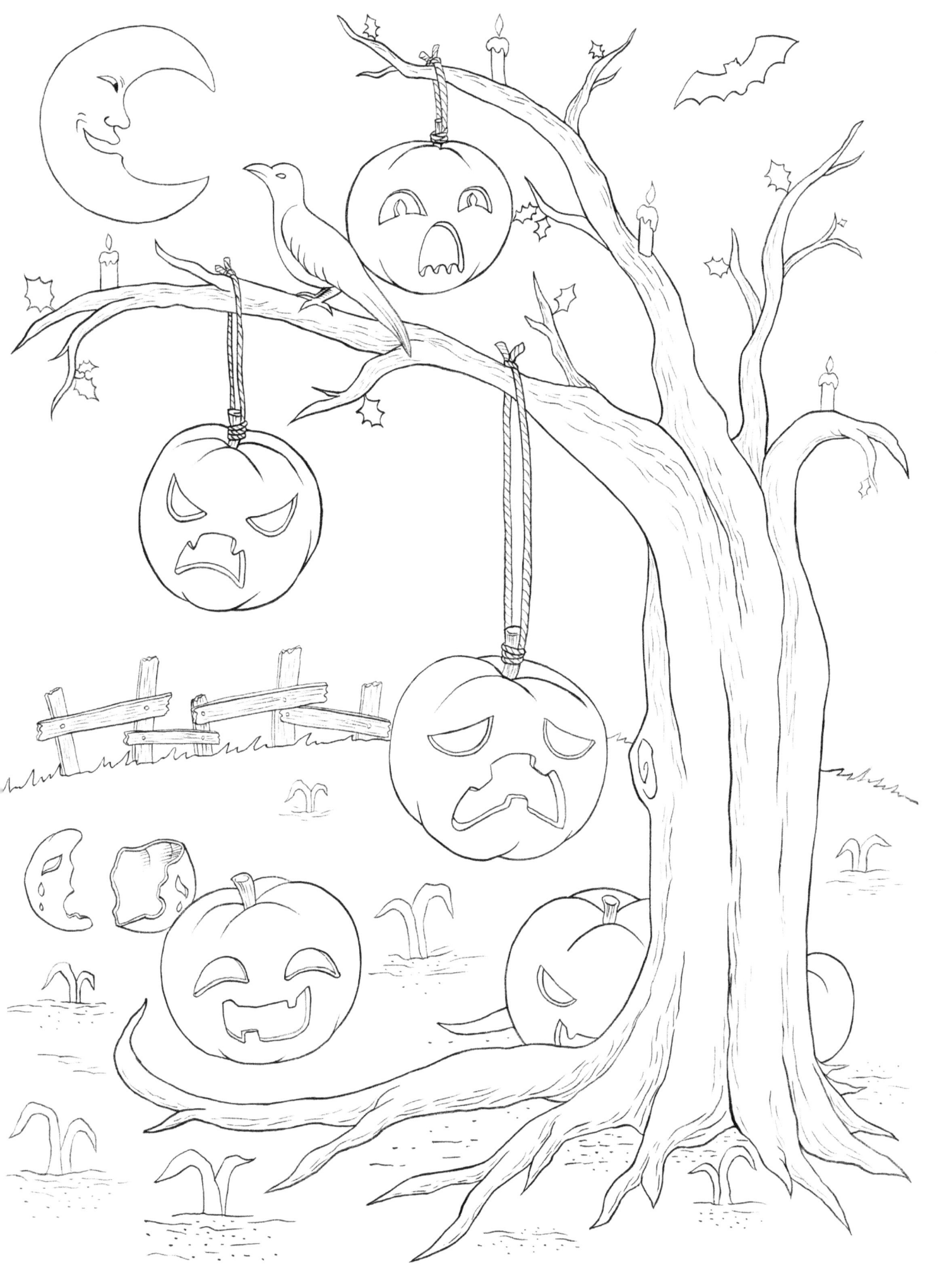

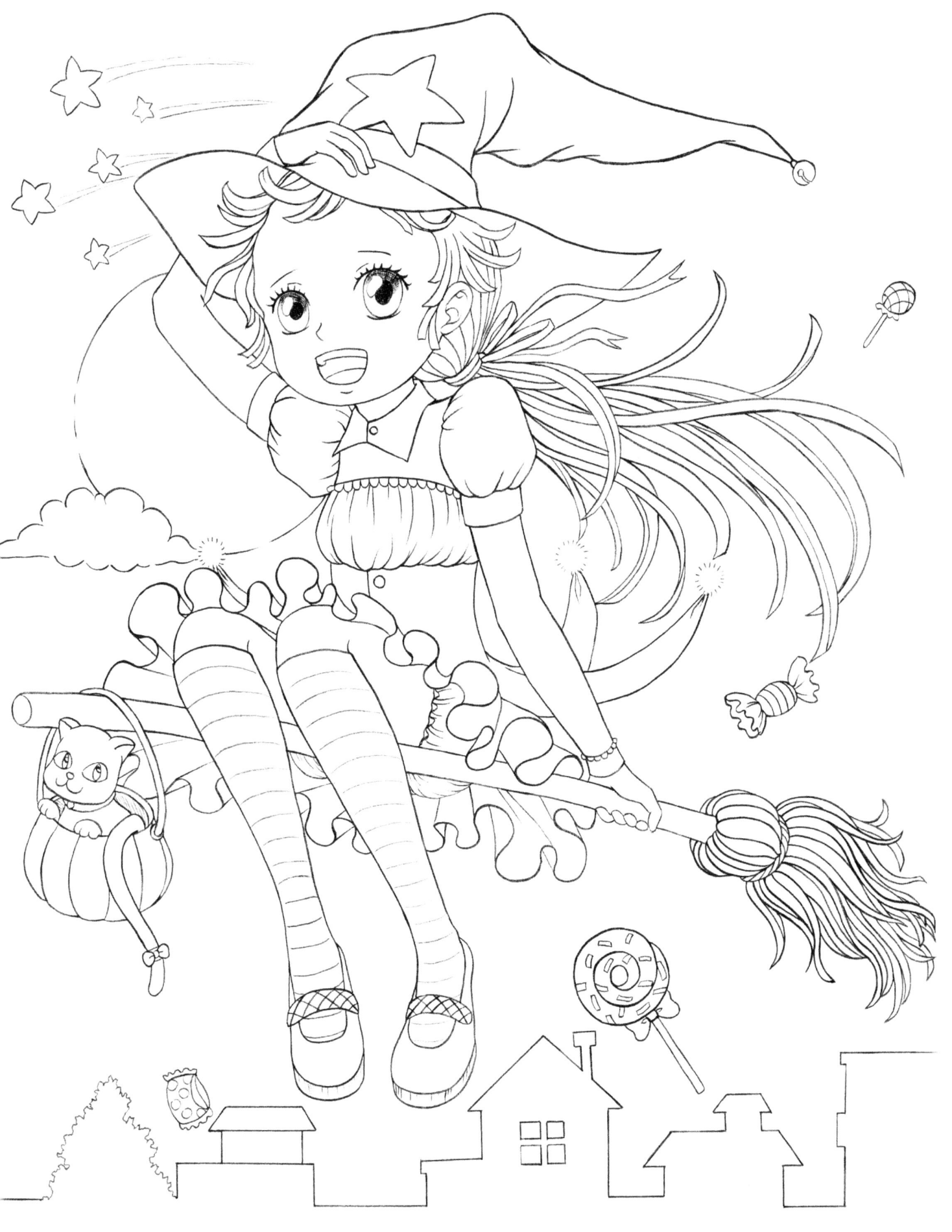

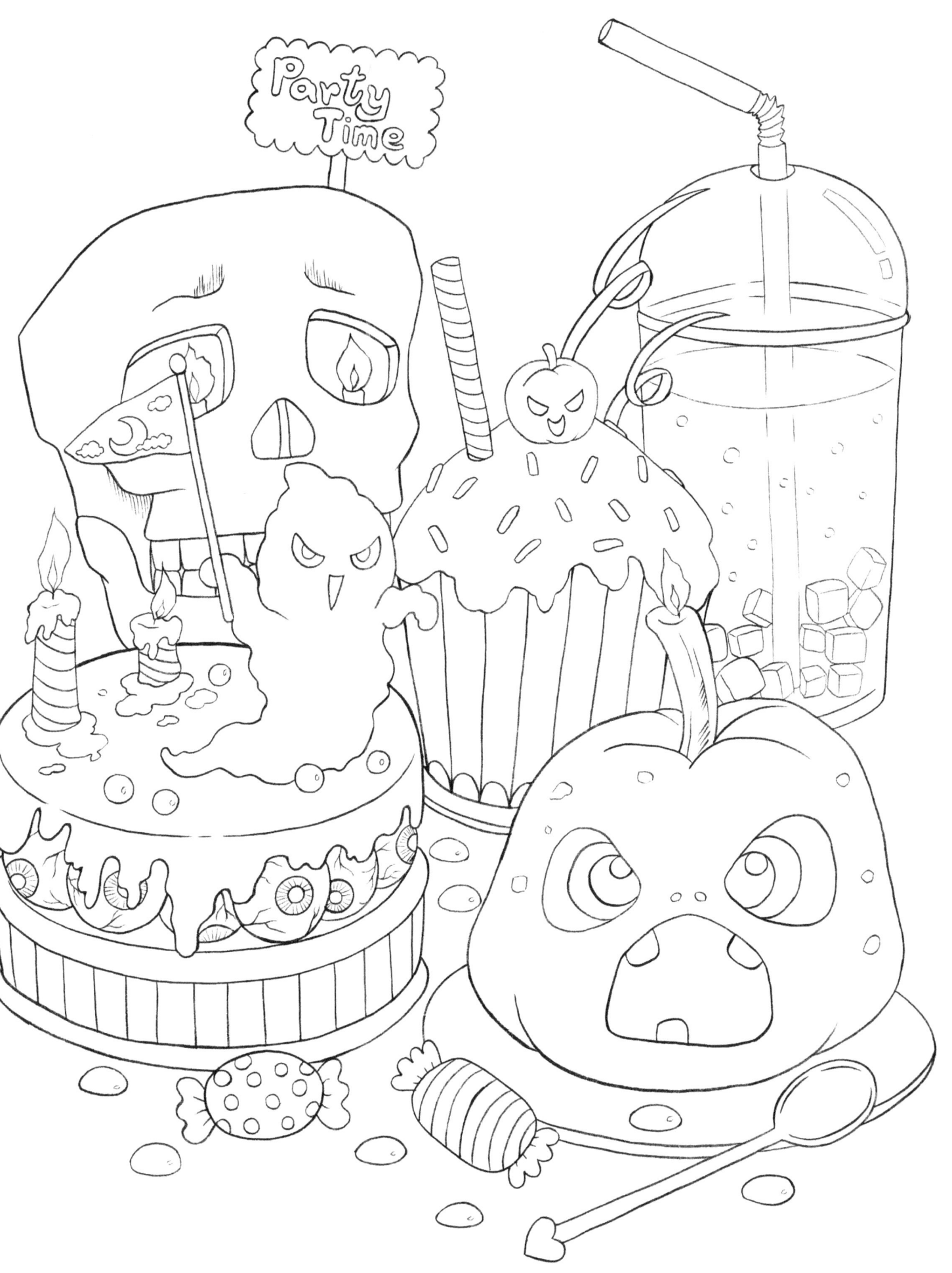

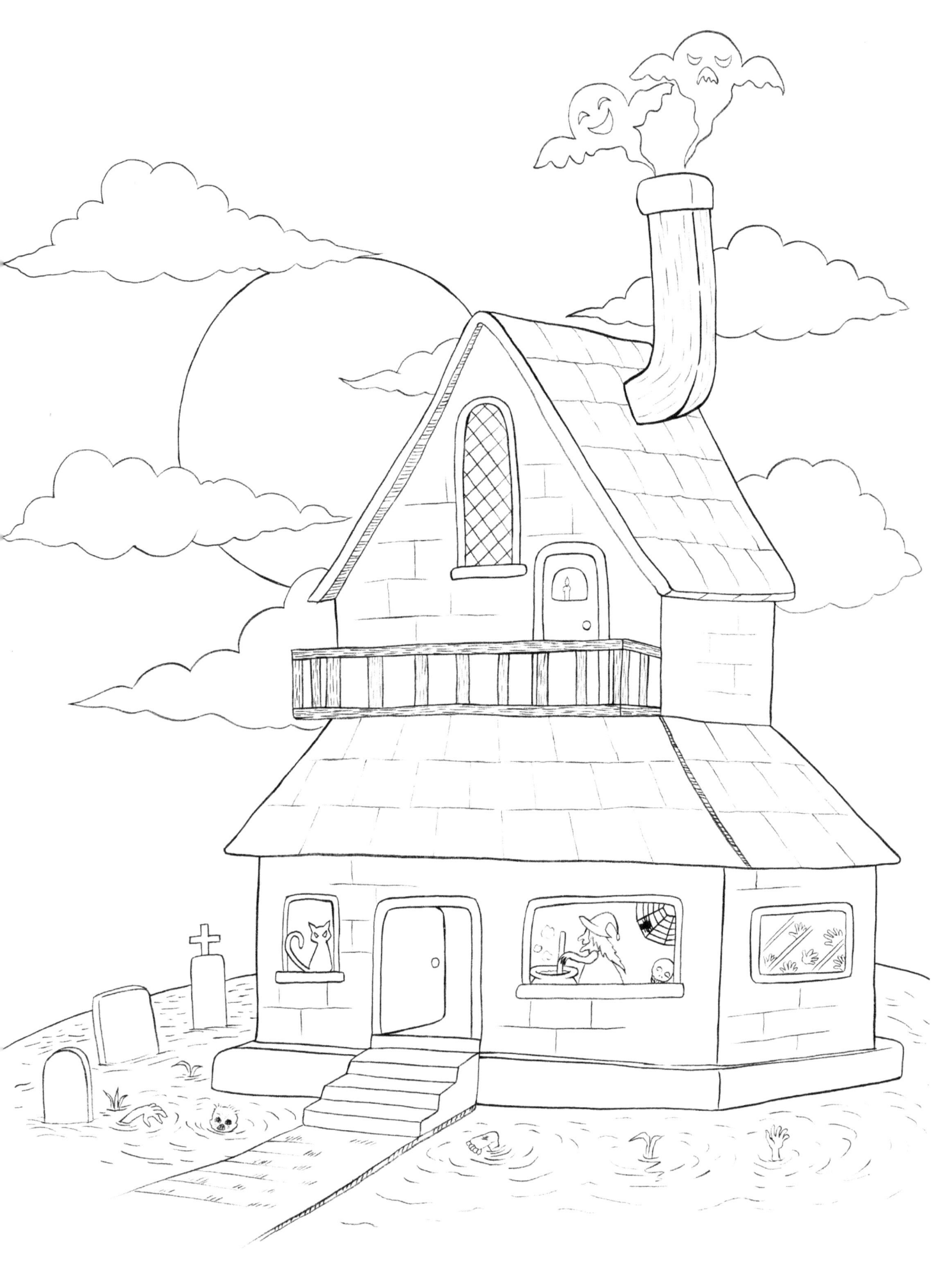

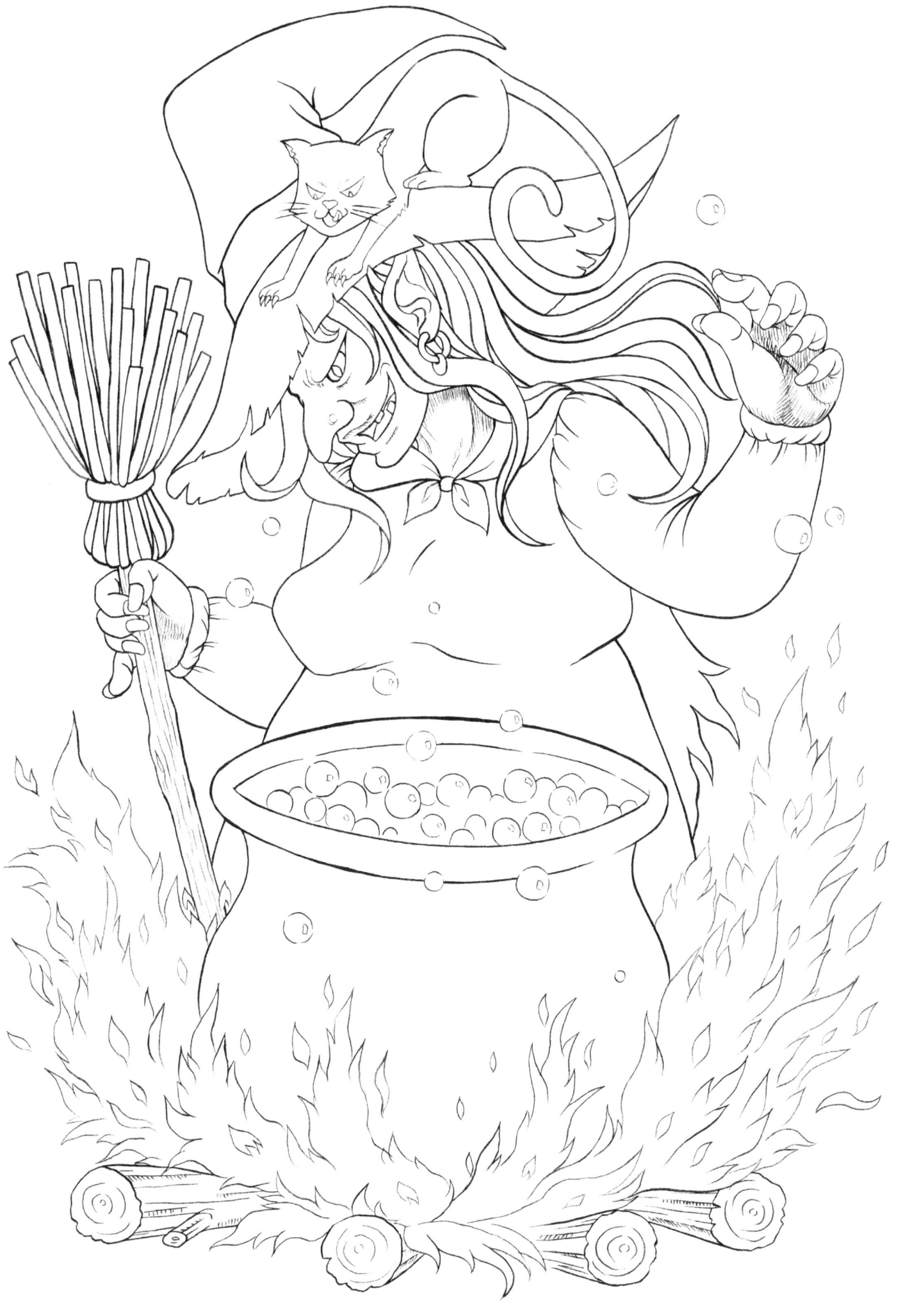

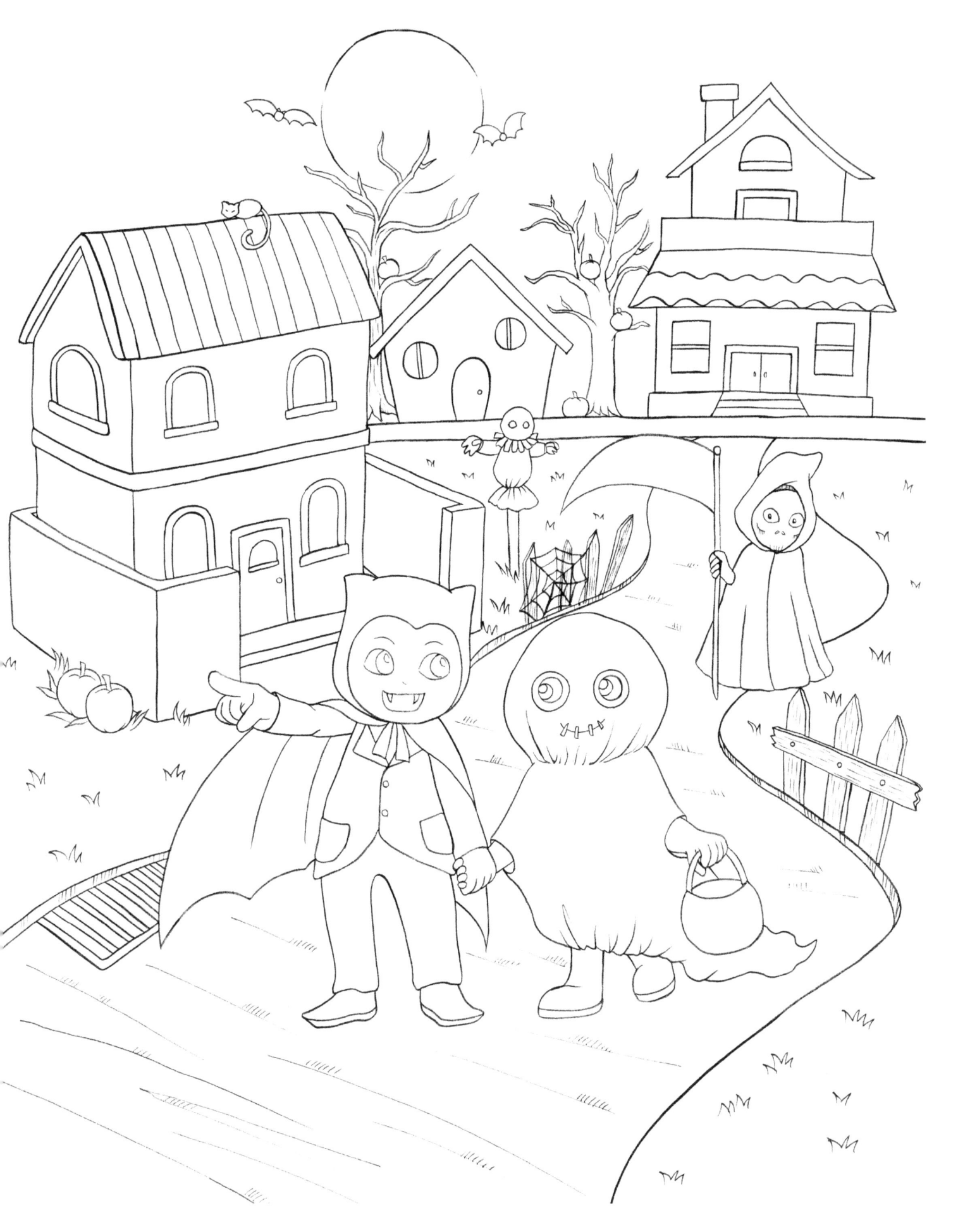

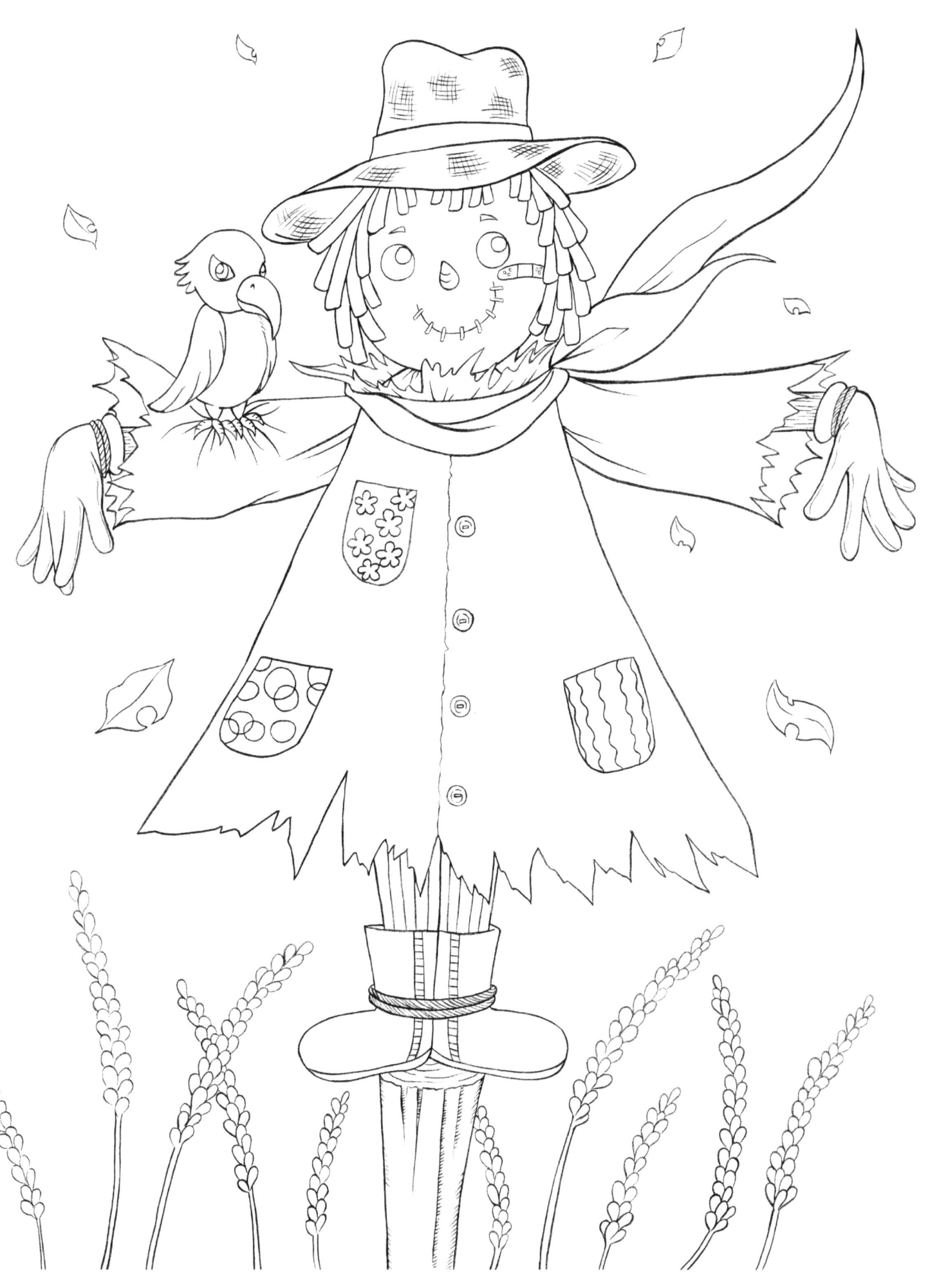

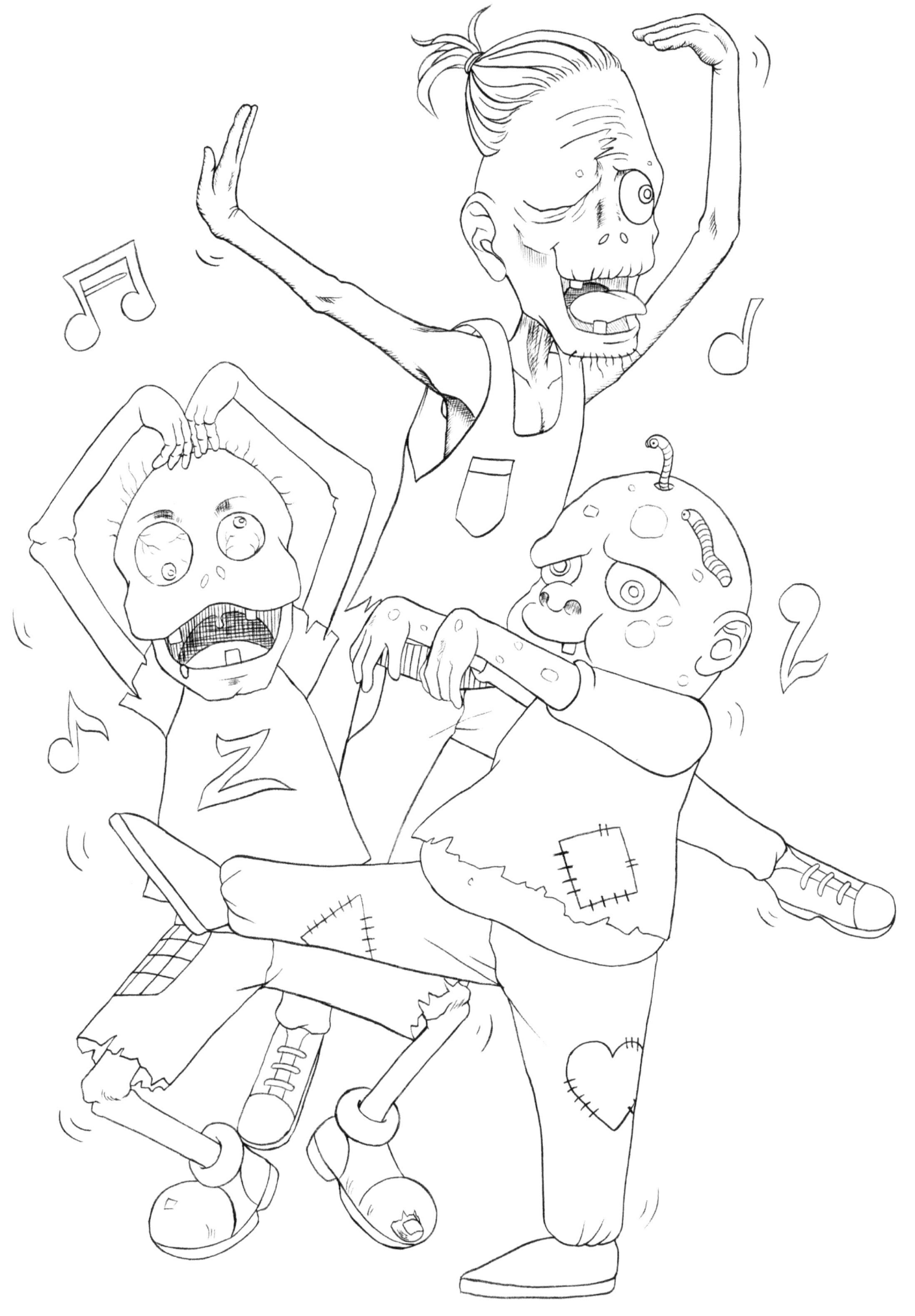

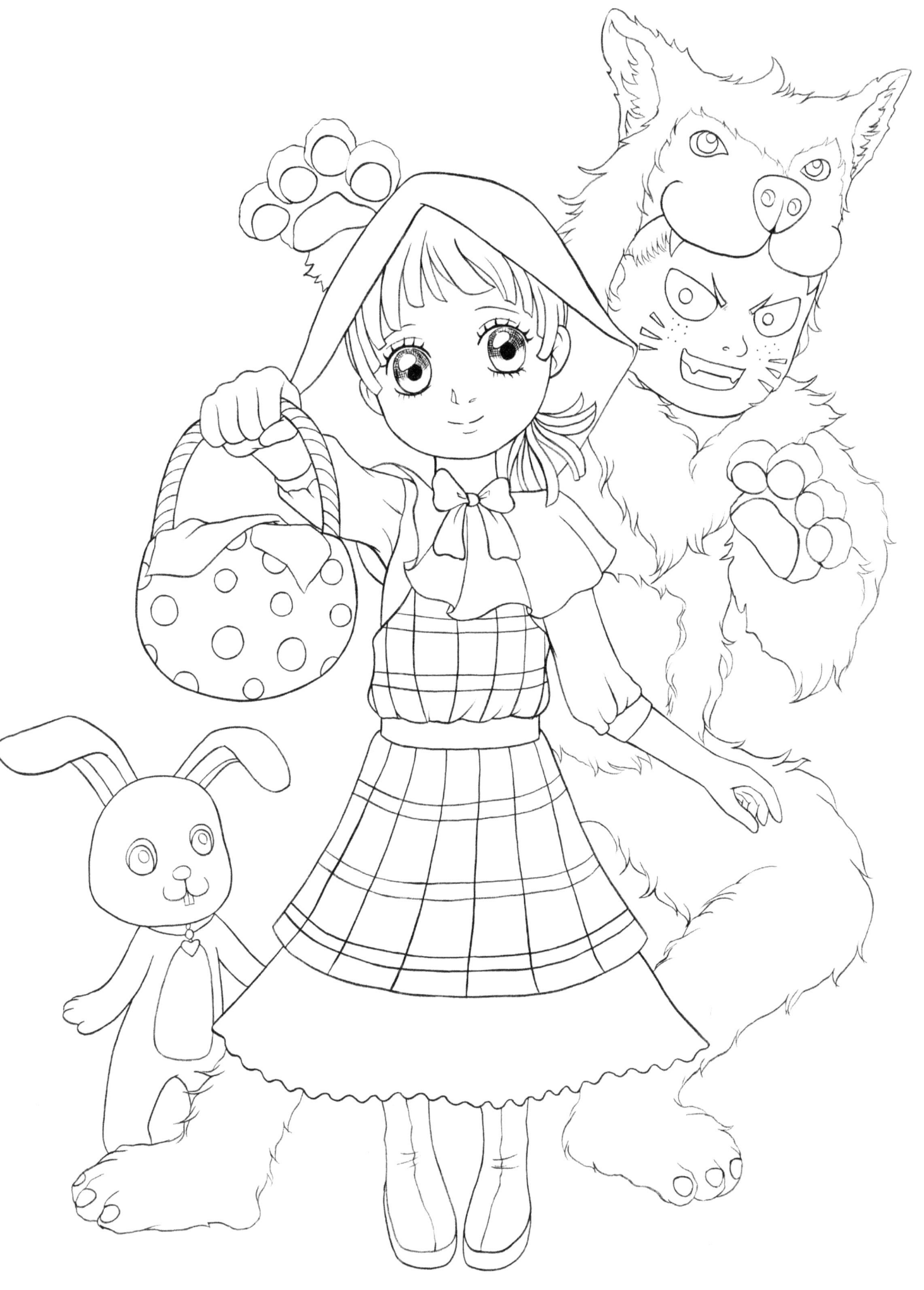

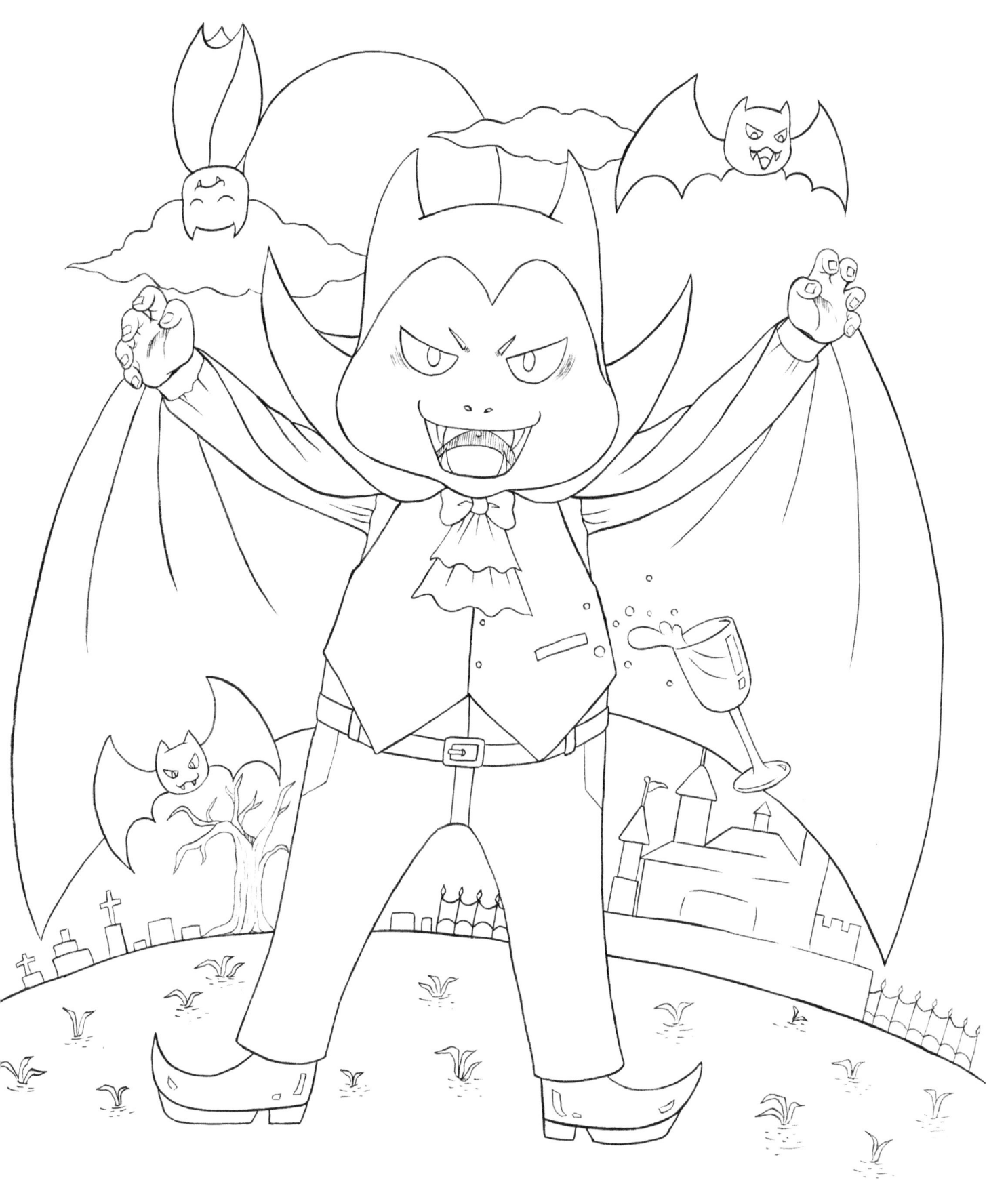

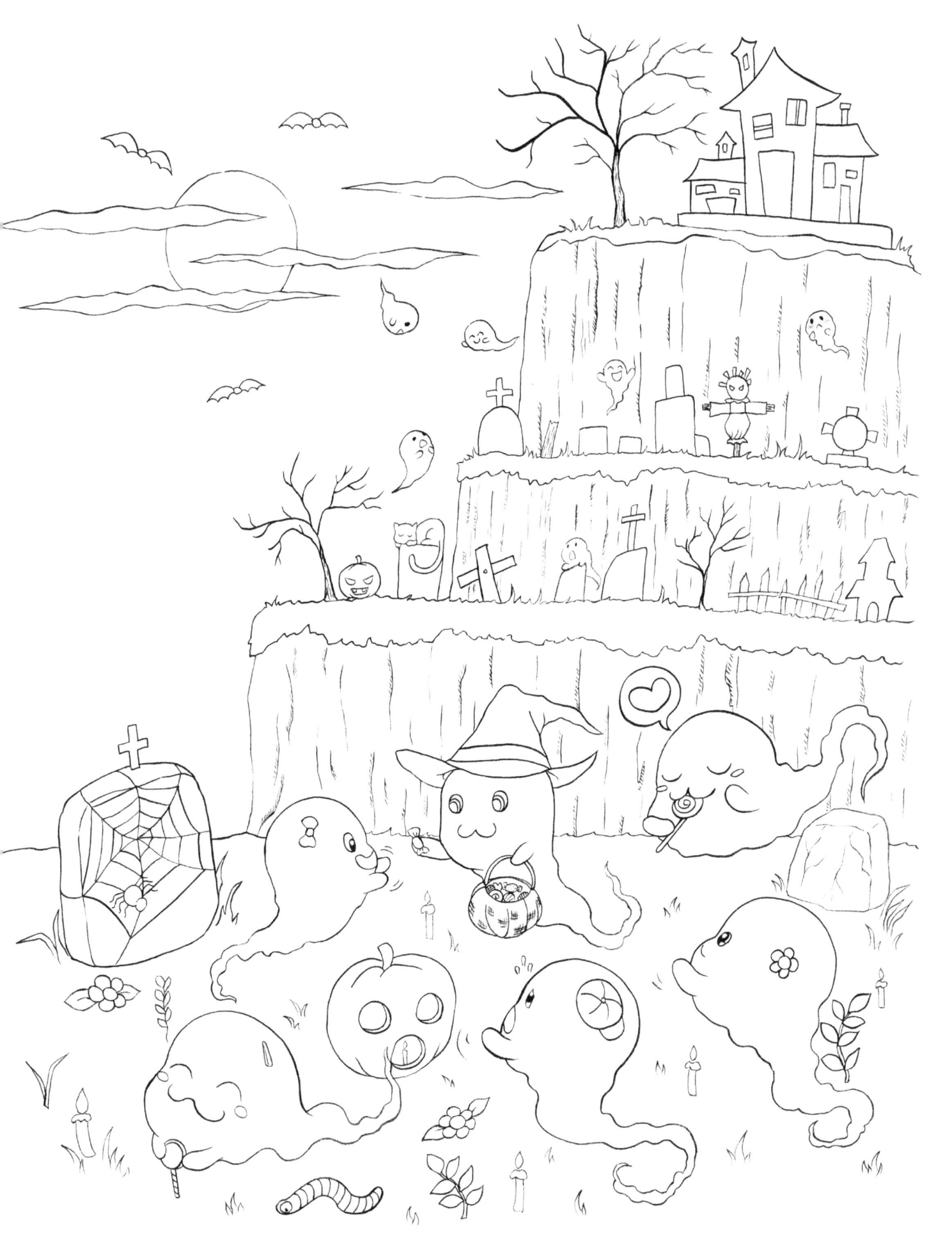

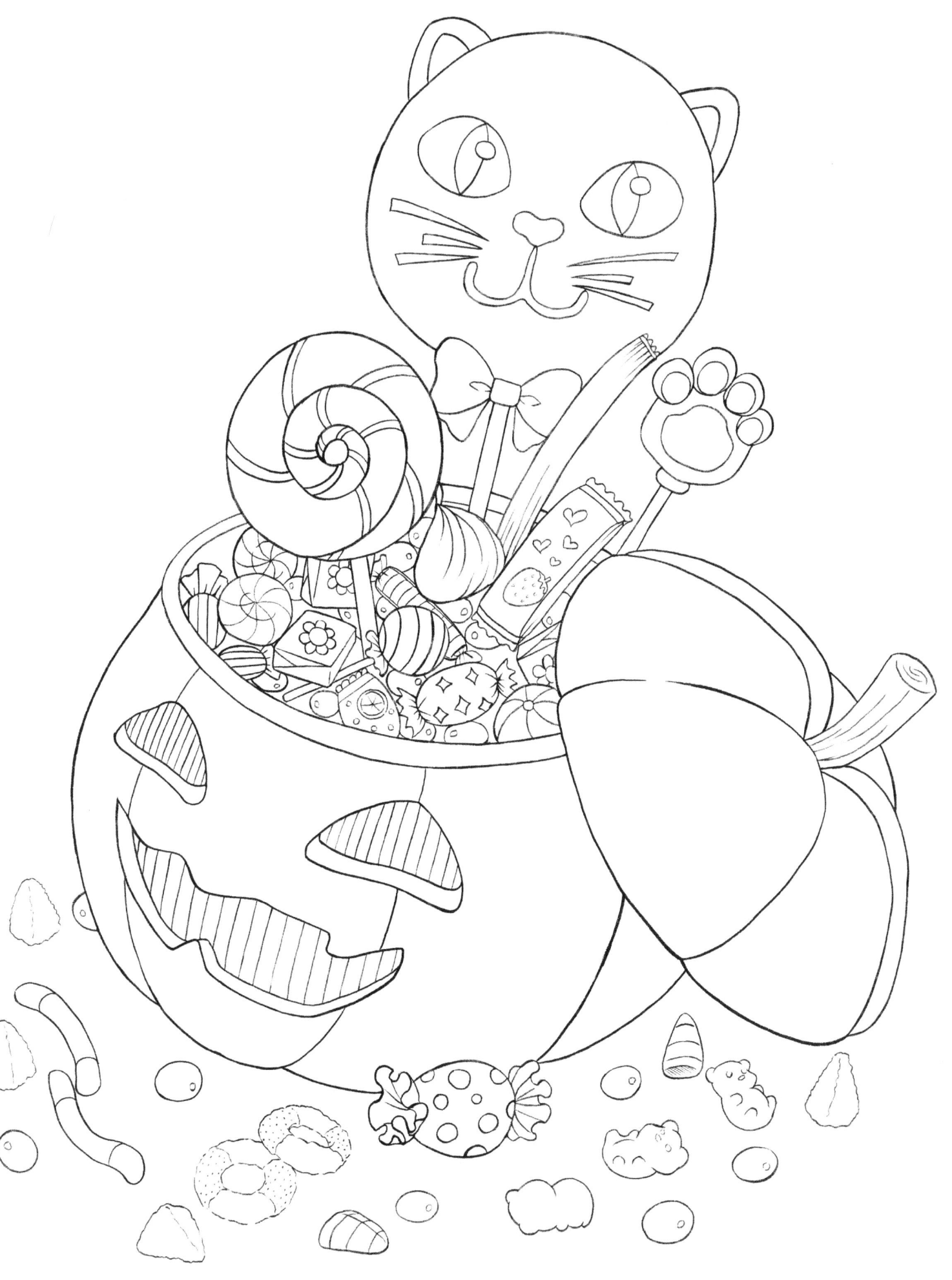

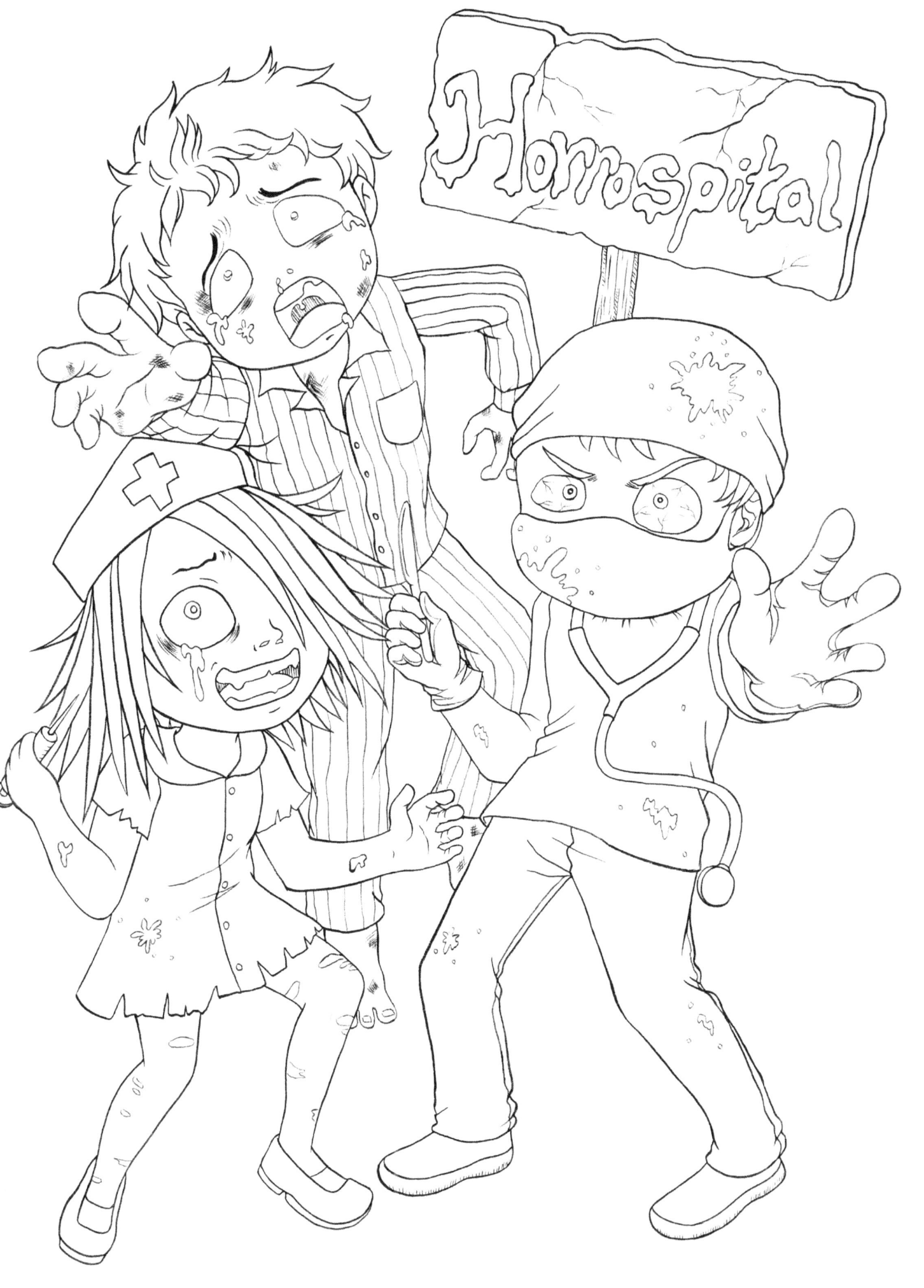

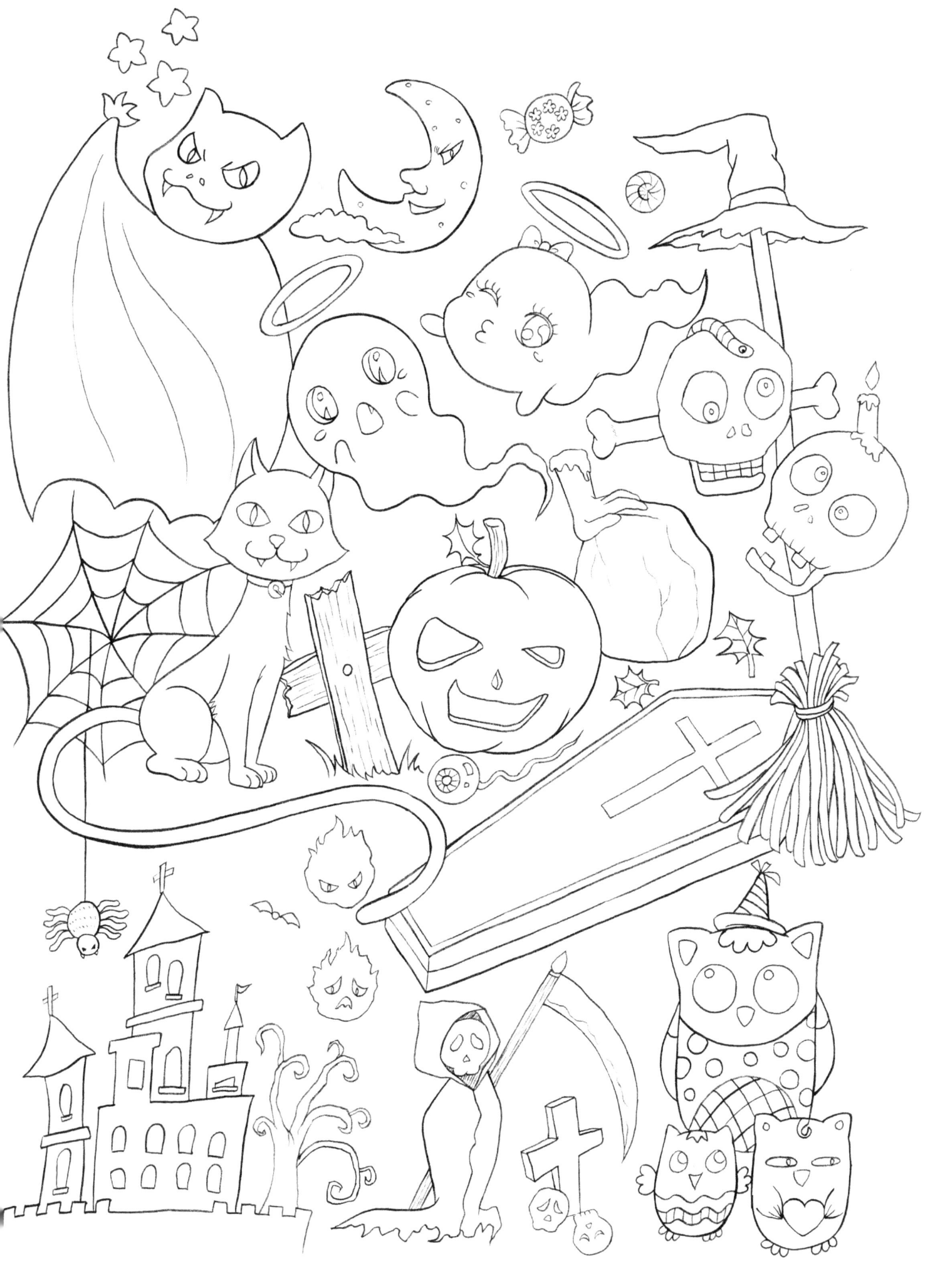

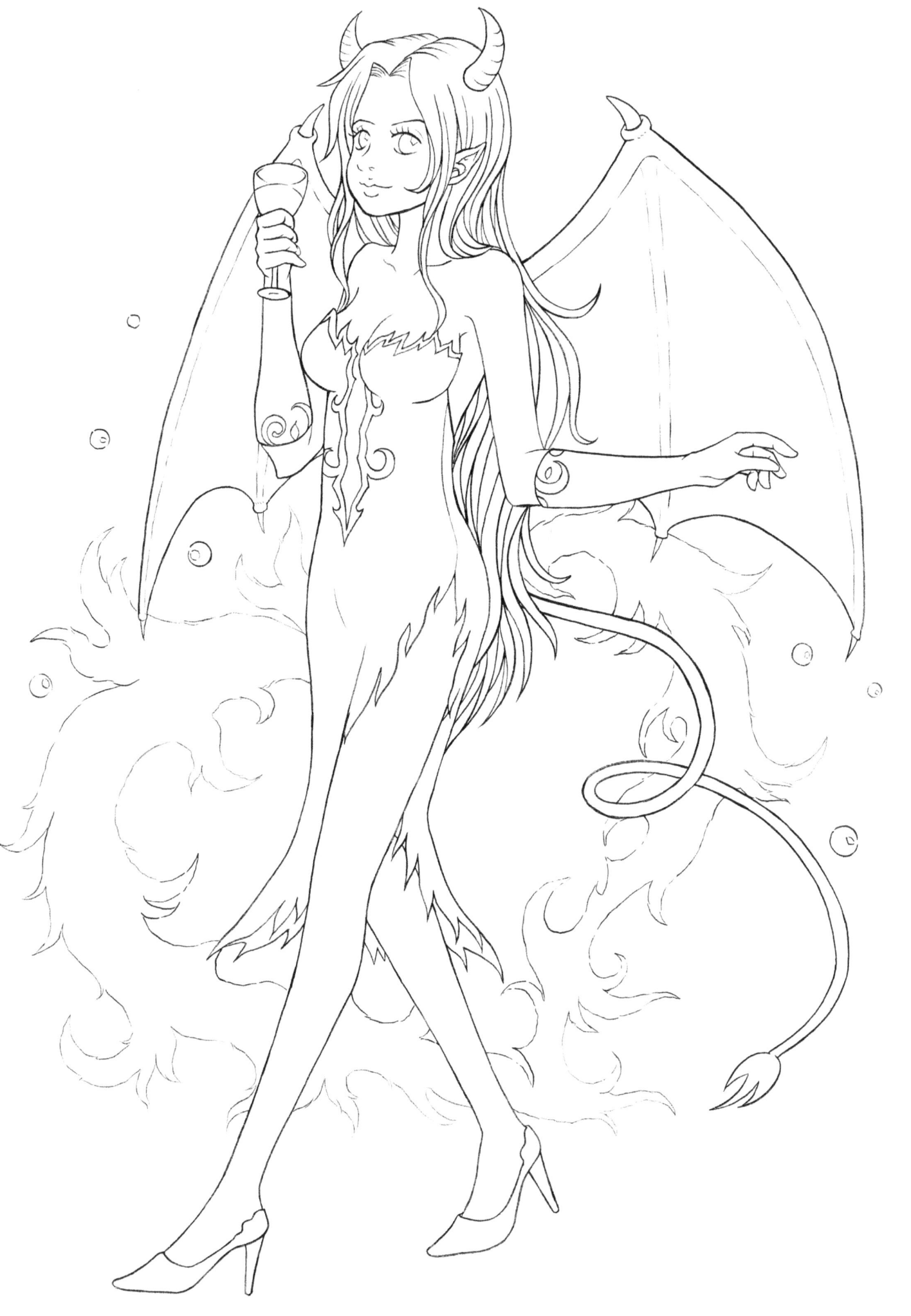

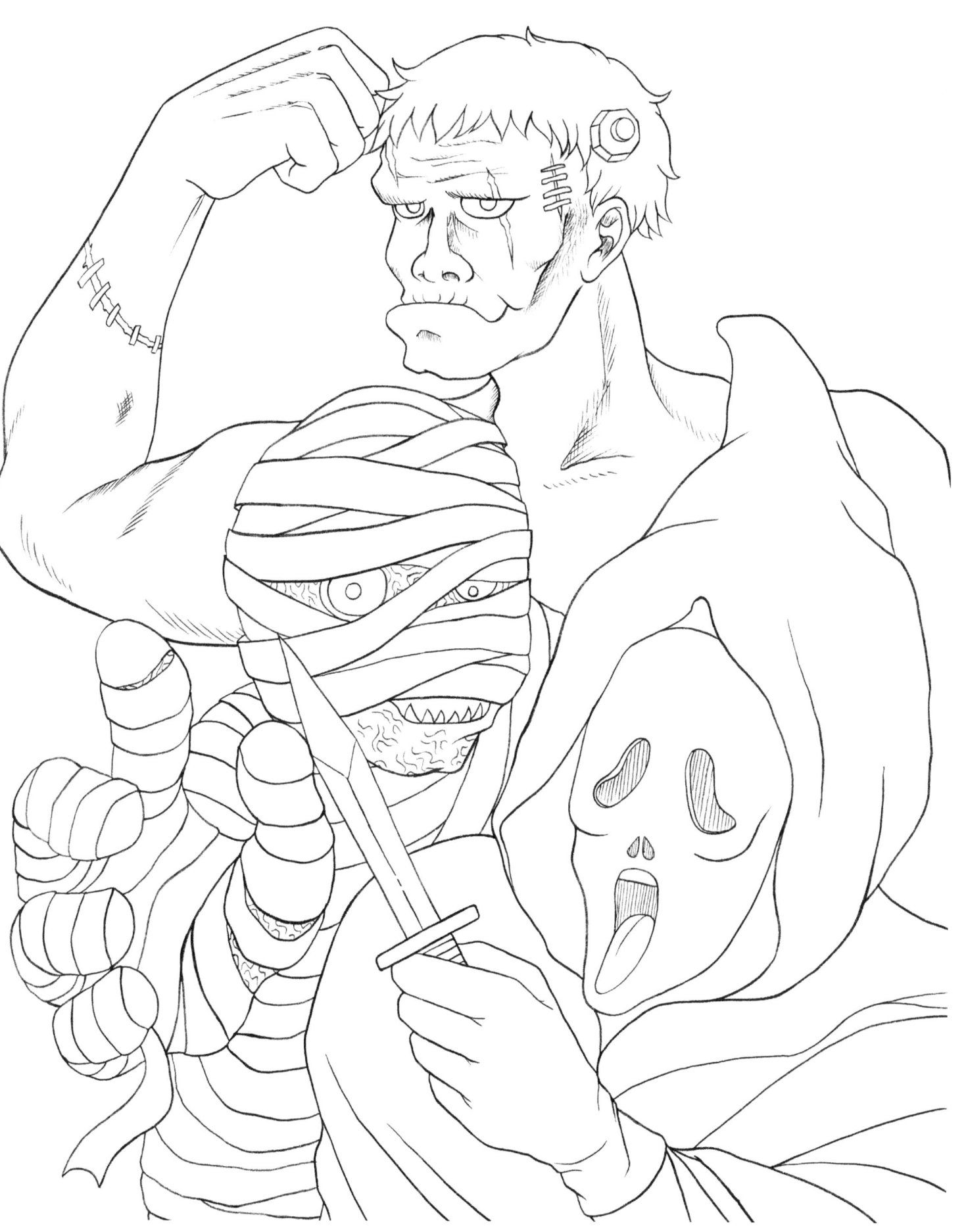

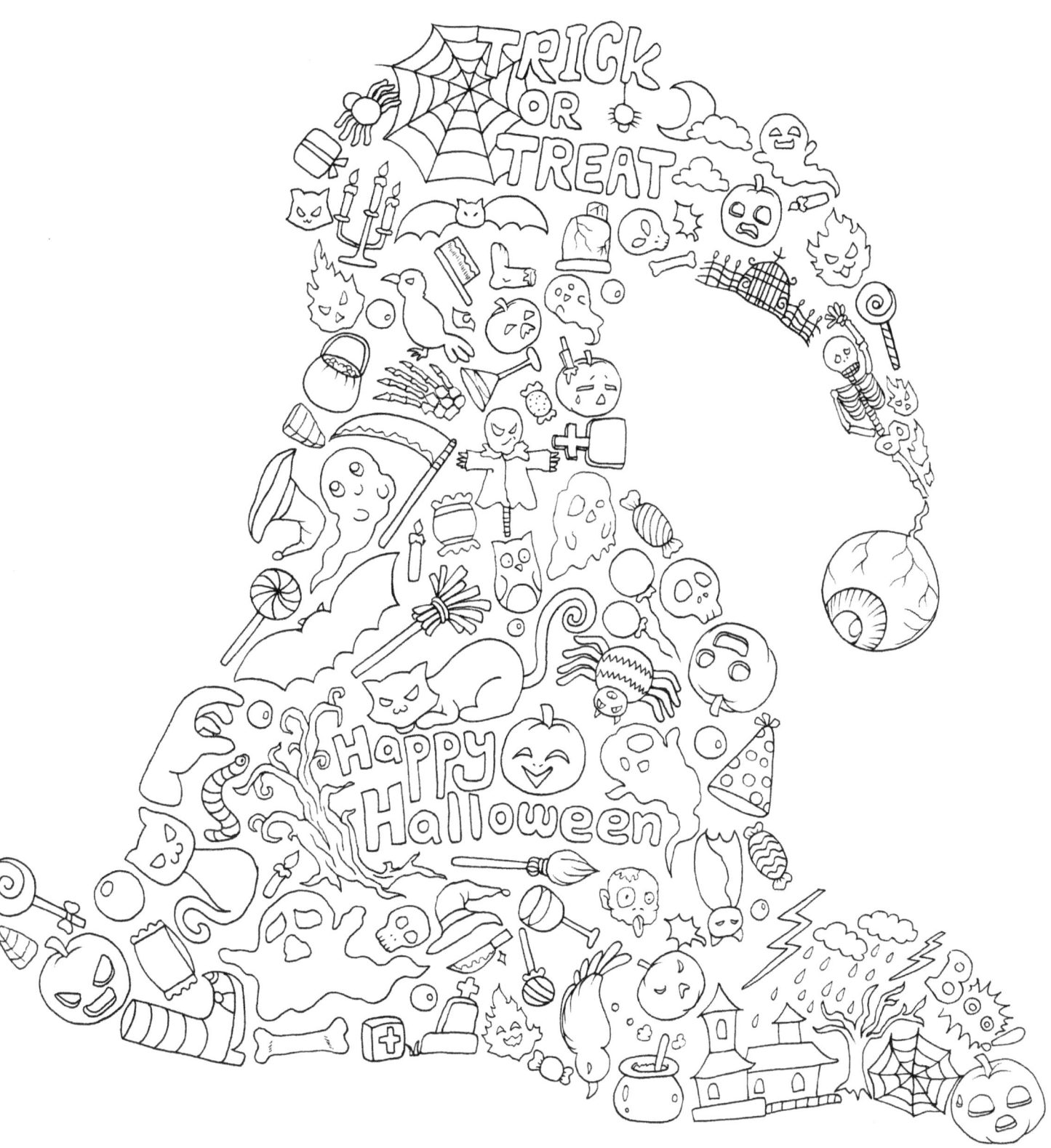

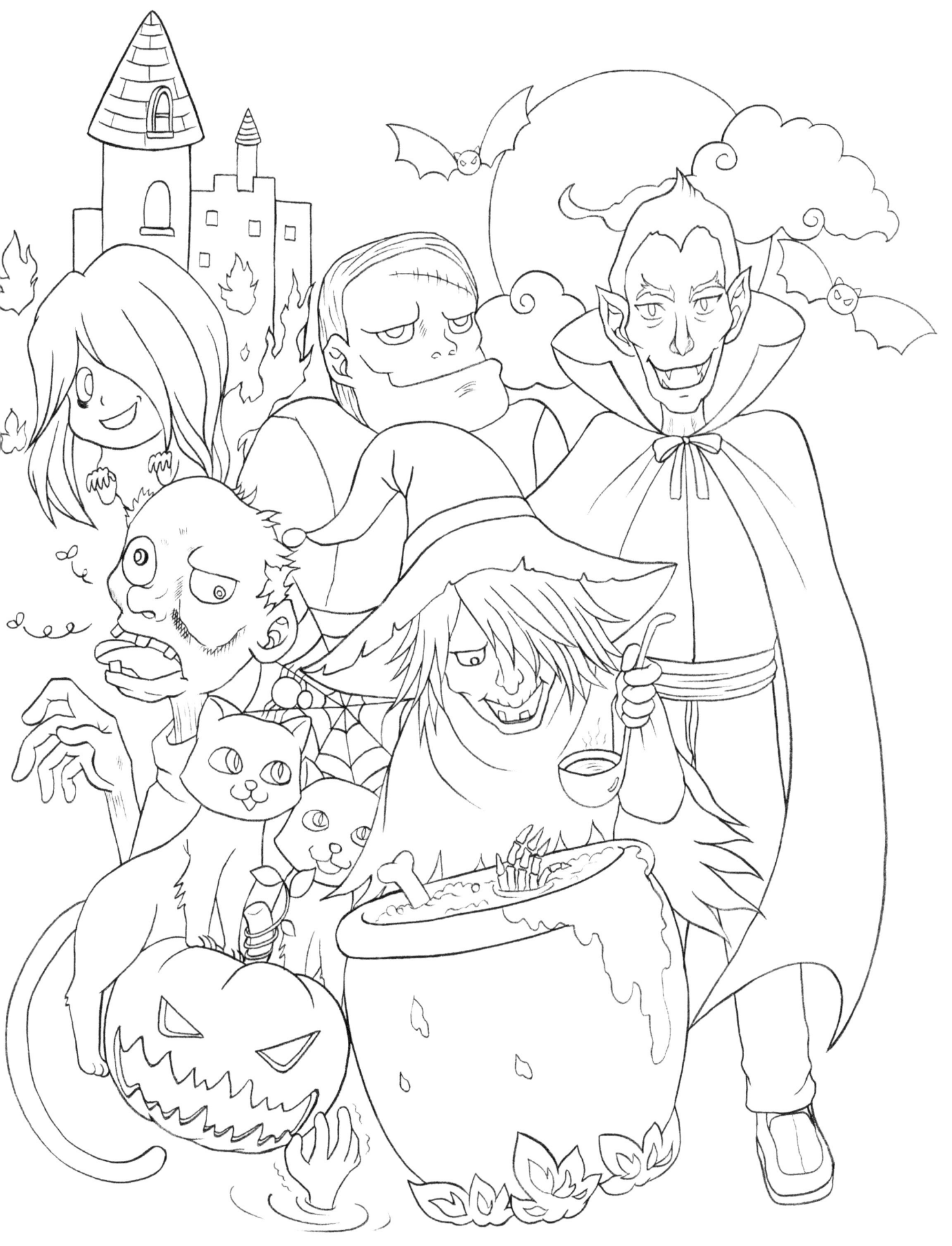

www.ingramcontent.com/pod-product-compliance
Lightning Source LLC
Chambersburg PA
CBHW080523190526
45169CB00008B/3031